STILETTO ART BOOK

© Copyright 2016 Modern Day Creations

All rights reserved. No part of this publication may be reproduced, distributed, or transmitted in any form or by any means, including photocopying, recording, or other electronic or mechanical methods, without the prior written permission of the publisher, except in the case of brief quotations embodied in critical reviews and certain other noncommercial uses permitted by copyright law. For permission requests, write to the publisher, addressed "Attention: Permissions Coordinator," Special discounts are available on quantity purchases by corporations, associations, and others.

For details, contact the publisher:

Modern Day Creations, 2240 Taylorsville Rd #103 Louisville, KY 40205

www.moderndaycreations.com

Designs by:

Dedicated to all stiletto lovers who feel confident, fearless and sexy when they slip on a pair of their favorite stilettos ready to conquer the world with a sassy strut and a sophisticated style.

Partial proceeds from each book will go towards domestic violence against women all over the world. Thank you for your contribution to this cause.

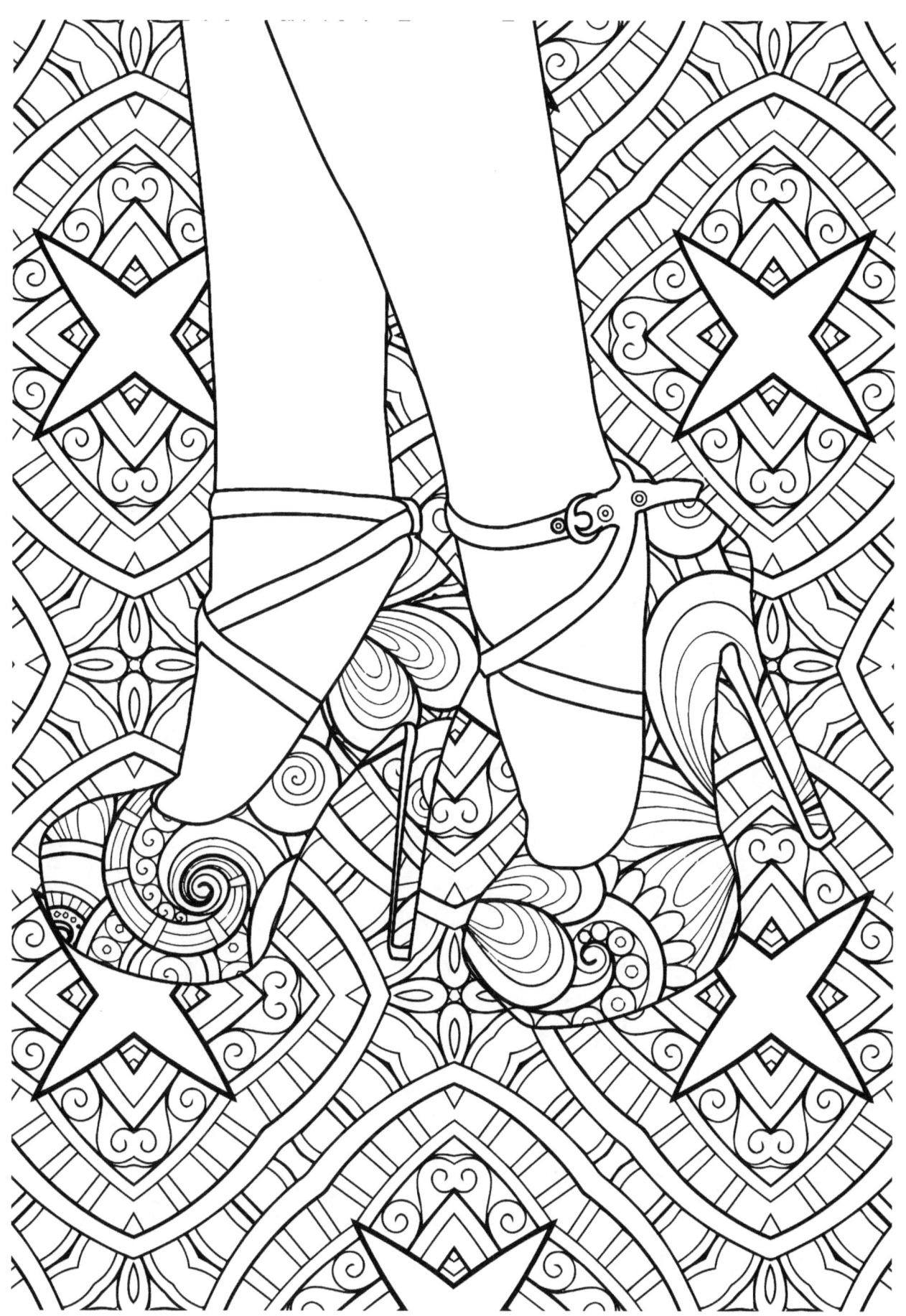

PALETTE BARS
*USE THESE SQUARES TO TEST YOUR COLORING MEDIUM AND PALETTE.
DONT BE AFRAID TO TRY DIFFERENT COLOR COMBINATIONS.*

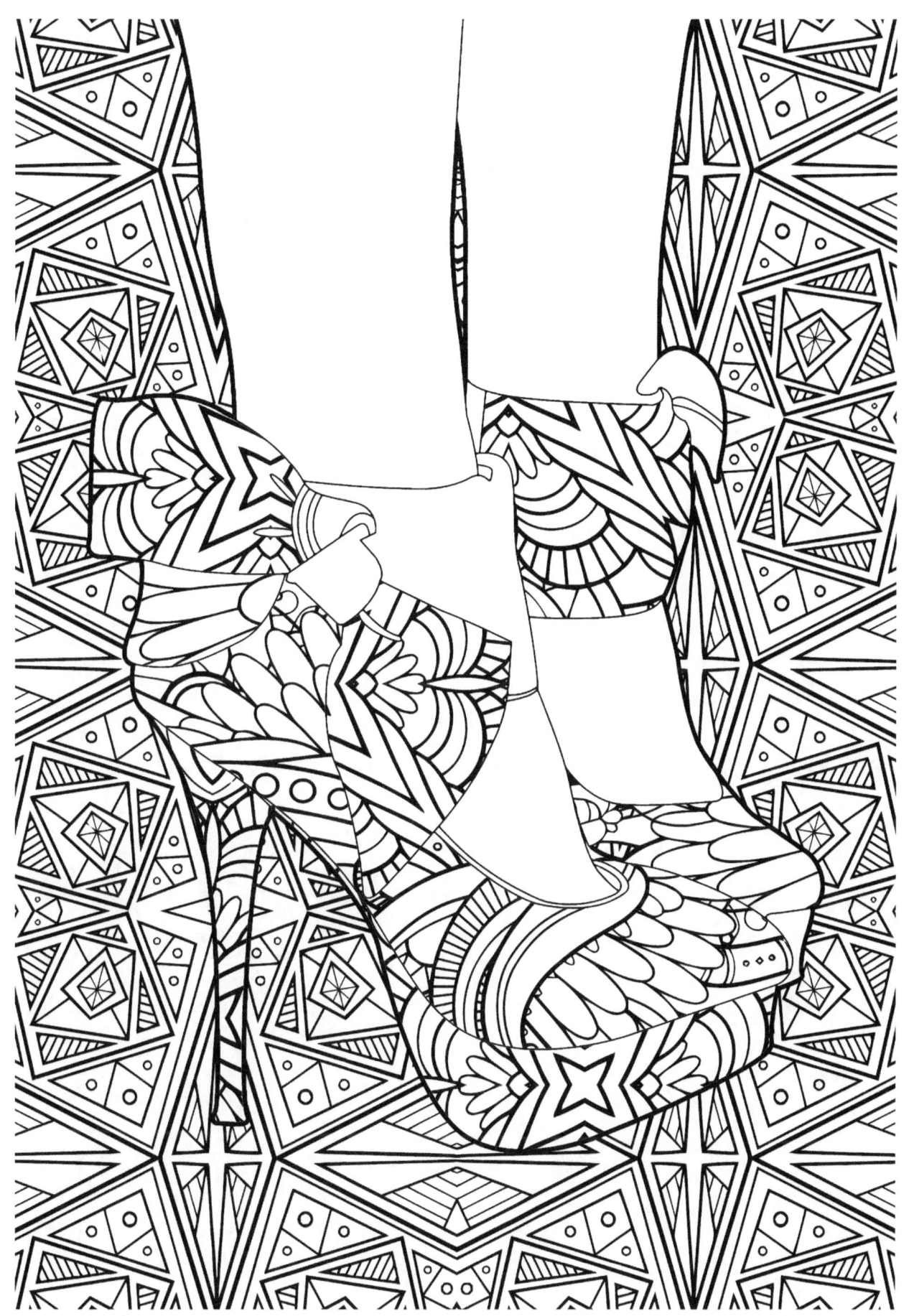

PALETTE BARS
*USE THESE SQUARES TO TEST YOUR COLORING MEDIUM AND PALETTE.
DONT BE AFRAID TO TRY DIFFERENT COLOR COMBINATIONS.*

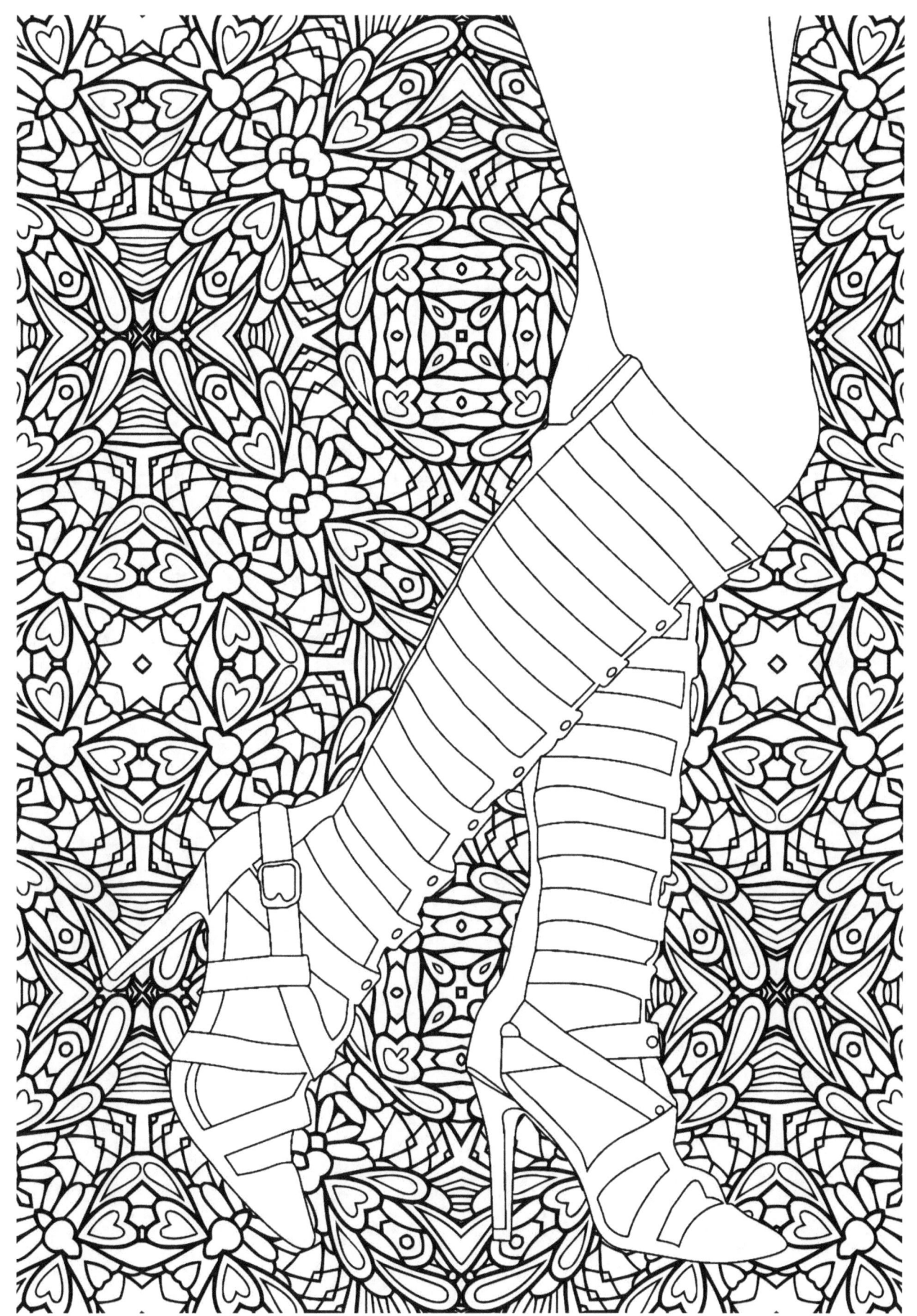

PALETTE BARS
USE THESE SQUARES TO TEST YOUR COLORING MEDIUM AND PALETTE.
DONT BE AFRAID TO TRY DIFFERENT COLOR COMBINATIONS.

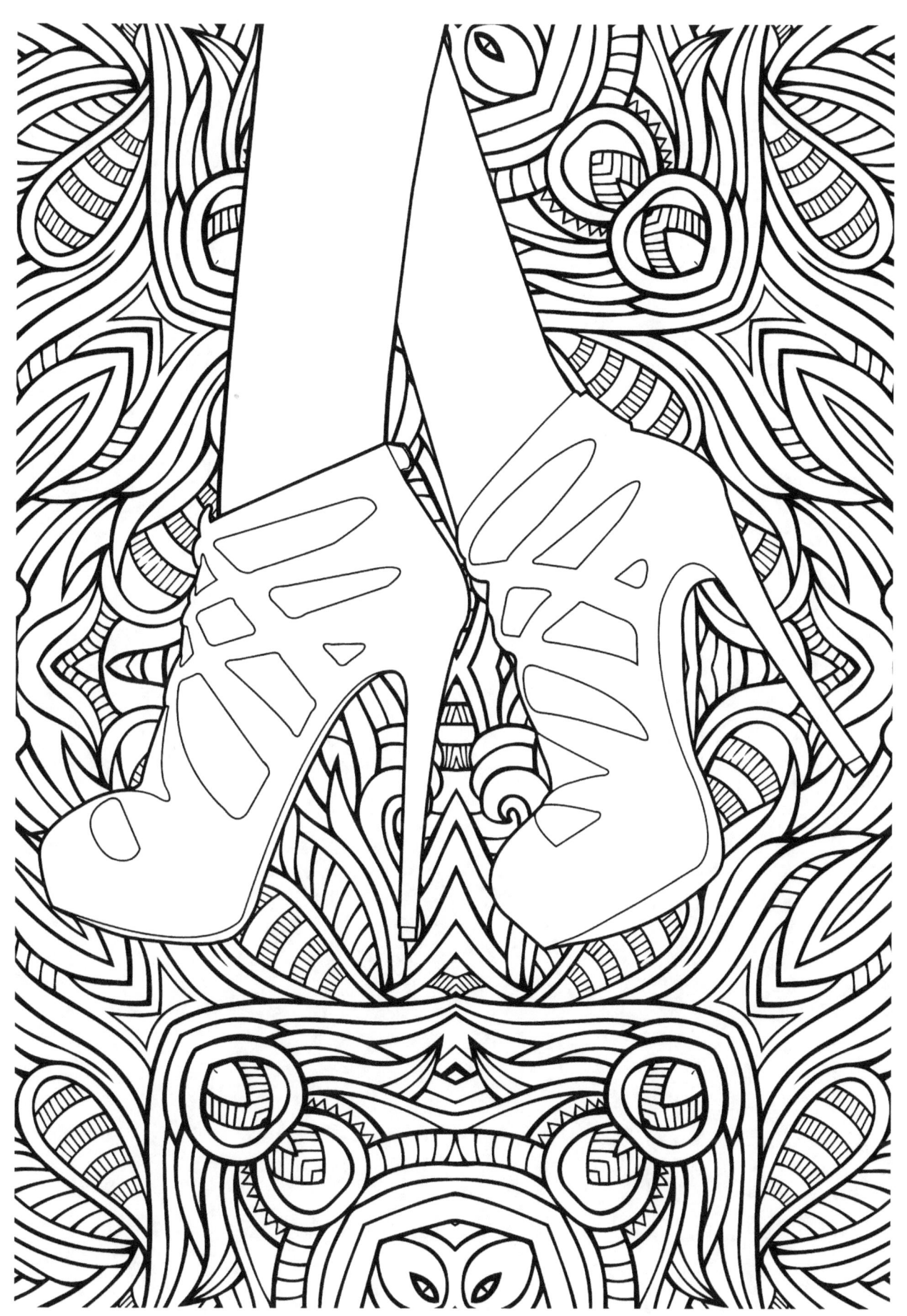

PALETTE BARS
*USE THESE SQUARES TO TEST YOUR COLORING MEDIUM AND PALETTE.
DONT BE AFRAID TO TRY DIFFERENT COLOR COMBINATIONS.*

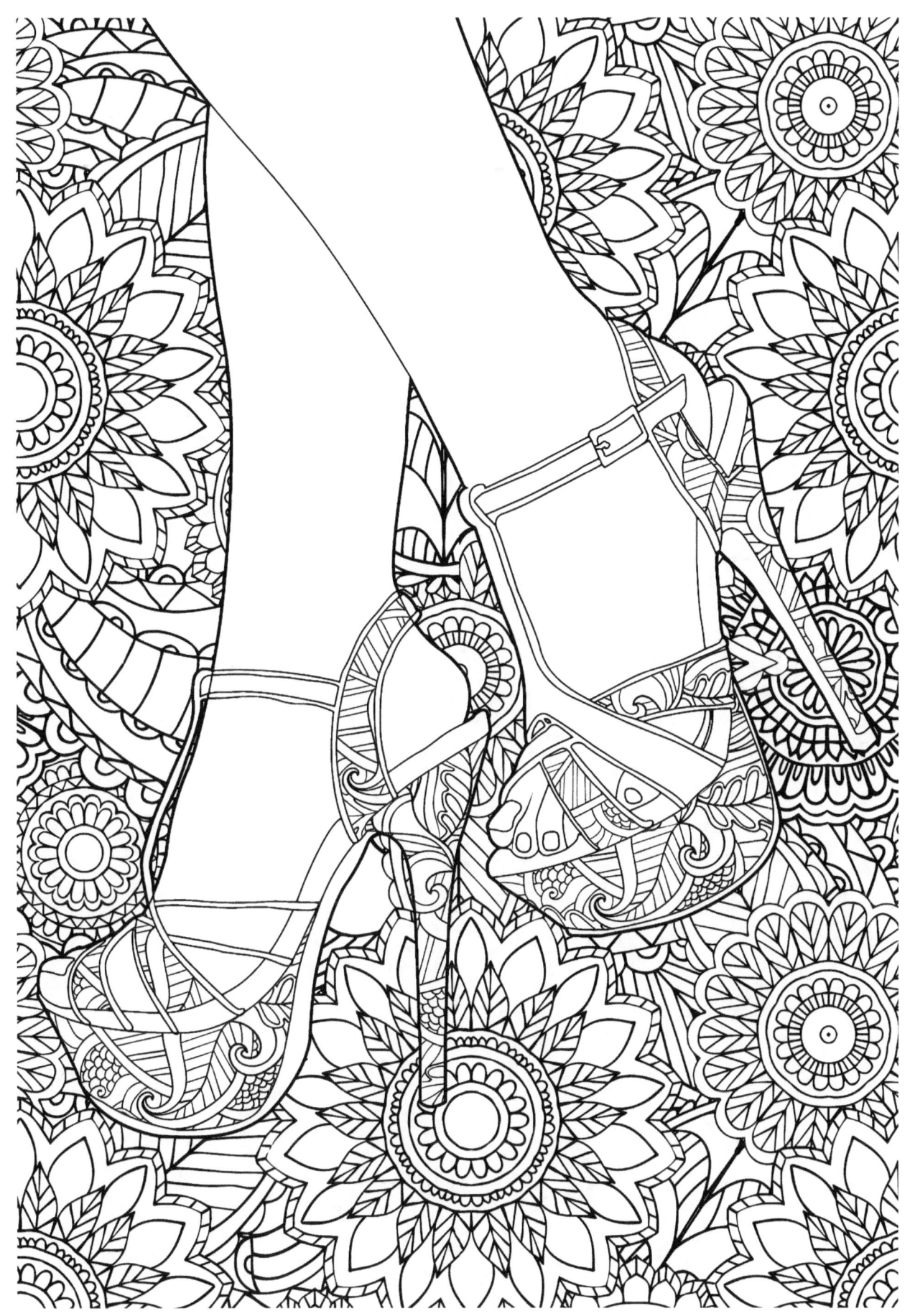

PALETTE BARS
USE THESE SQUARES TO TEST YOUR COLORING MEDIUM AND PALETTE.
DONT BE AFRAID TO TRY DIFFERENT COLOR COMBINATIONS.

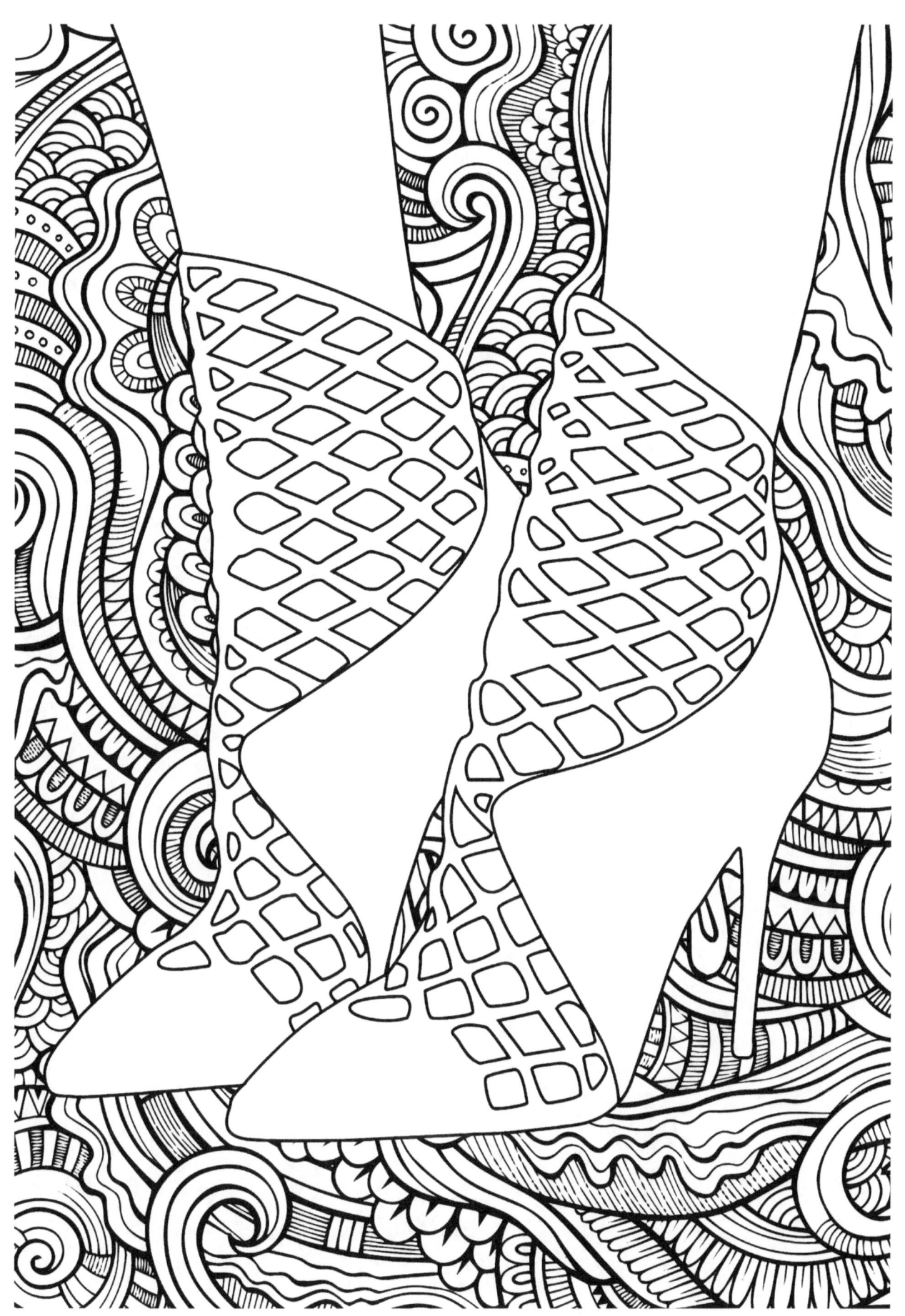

PALETTE BARS
*USE THESE SQUARES TO TEST YOUR COLORING MEDIUM AND PALETTE.
DONT BE AFRAID TO TRY DIFFERENT COLOR COMBINATIONS.*

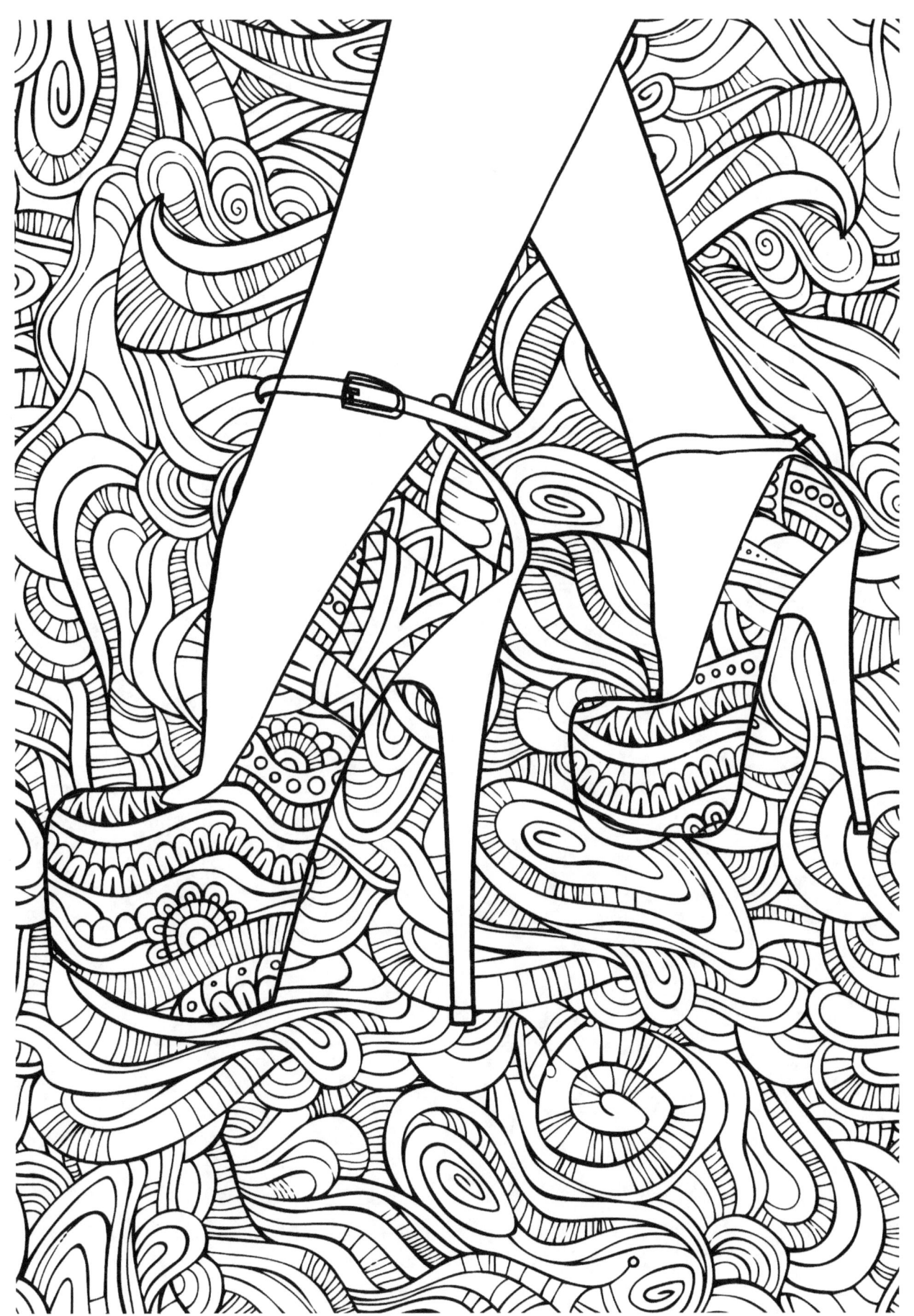

PALETTE BARS
*USE THESE SQUARES TO TEST YOUR COLORING MEDIUM AND PALETTE.
DONT BE AFRAID TO TRY DIFFERENT COLOR COMBINATIONS.*

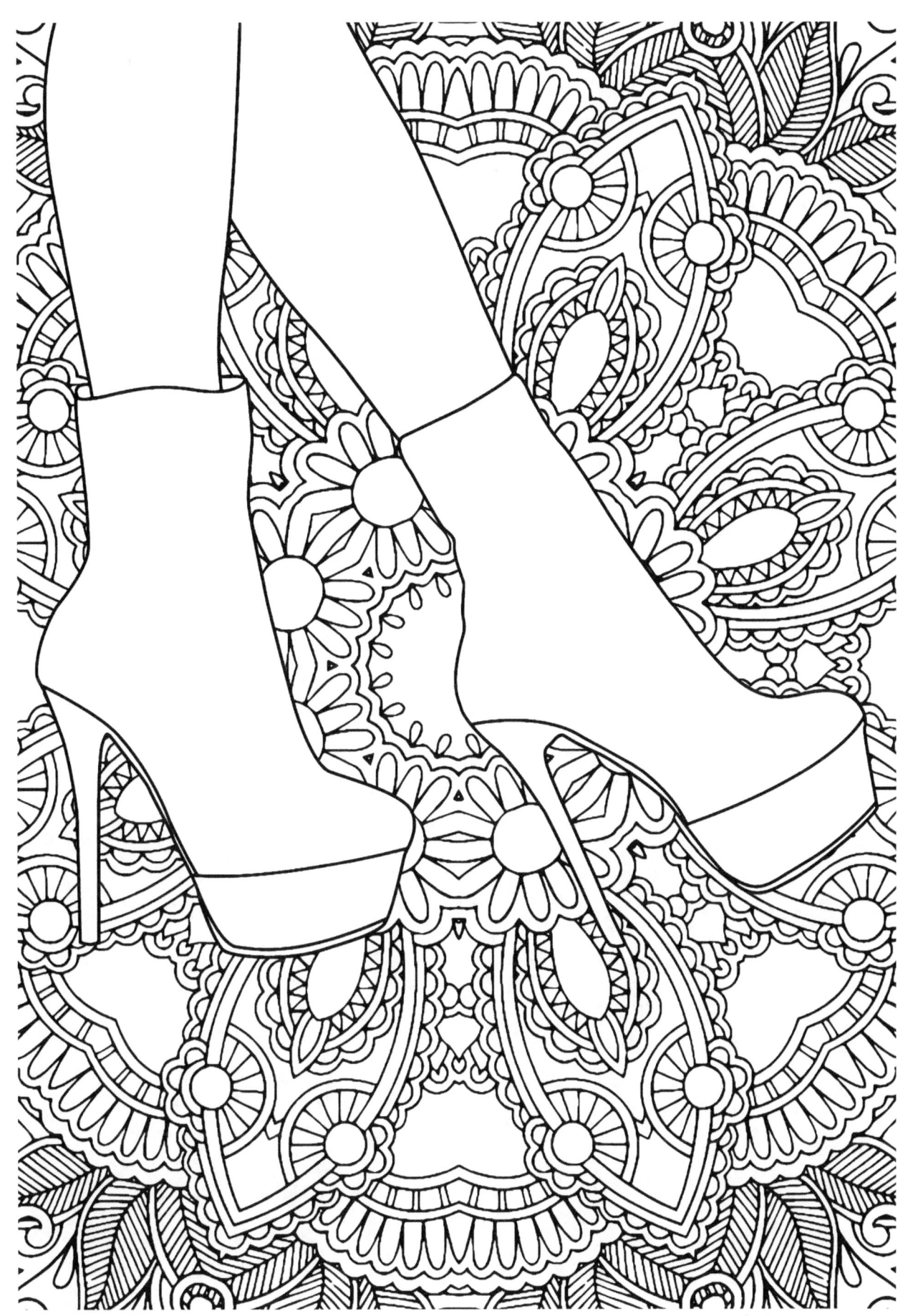

PALETTE BARS
USE THESE SQUARES TO TEST YOUR COLORING MEDIUM AND PALETTE.
DONT BE AFRAID TO TRY DIFFERENT COLOR COMBINATIONS.

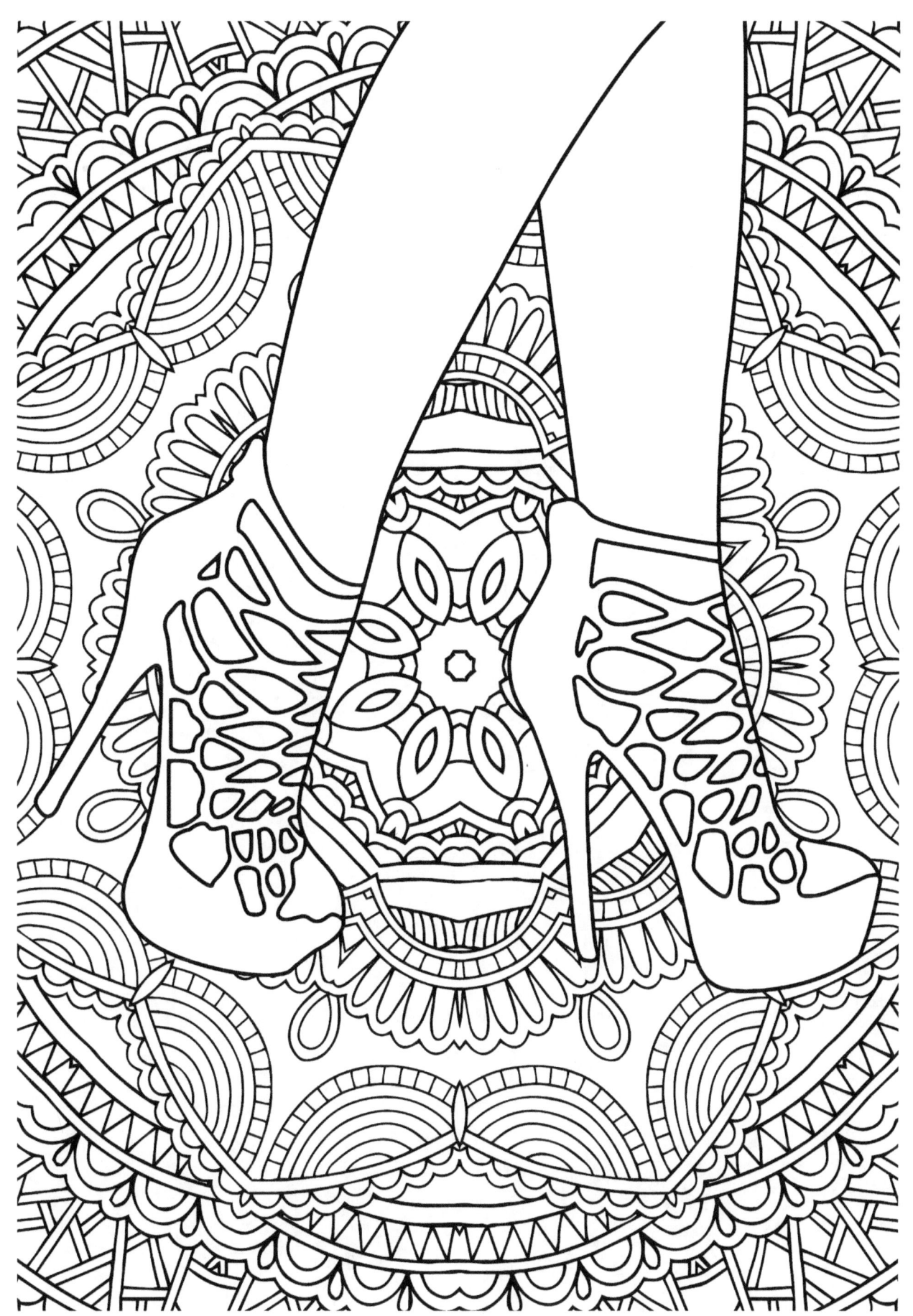

PALETTE BARS
*USE THESE SQUARES TO TEST YOUR COLORING MEDIUM AND PALETTE.
DONT BE AFRAID TO TRY DIFFERENT COLOR COMBINATIONS.*

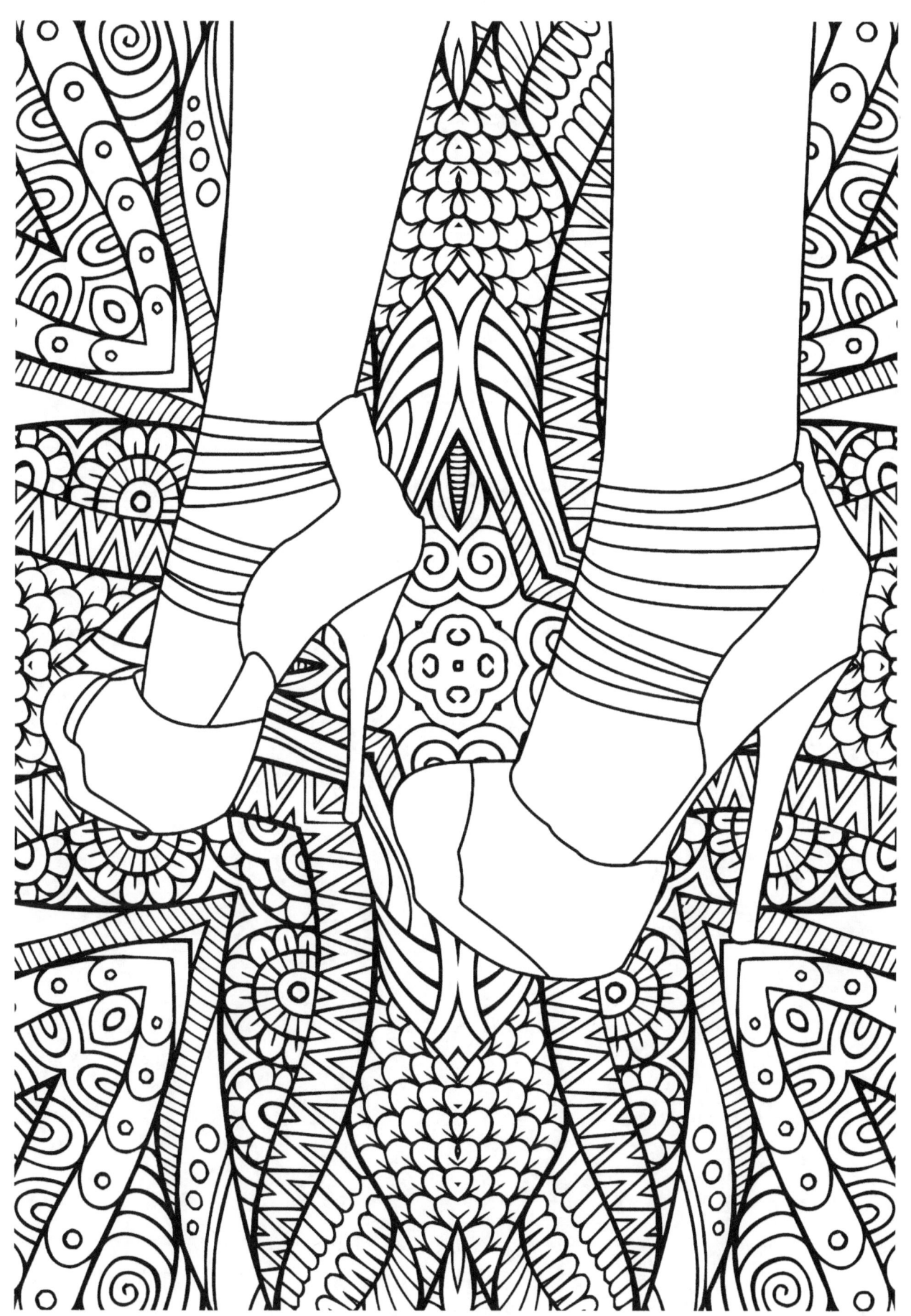

PALETTE BARS
*USE THESE SQUARES TO TEST YOUR COLORING MEDIUM AND PALETTE.
DONT BE AFRAID TO TRY DIFFERENT COLOR COMBINATIONS.*

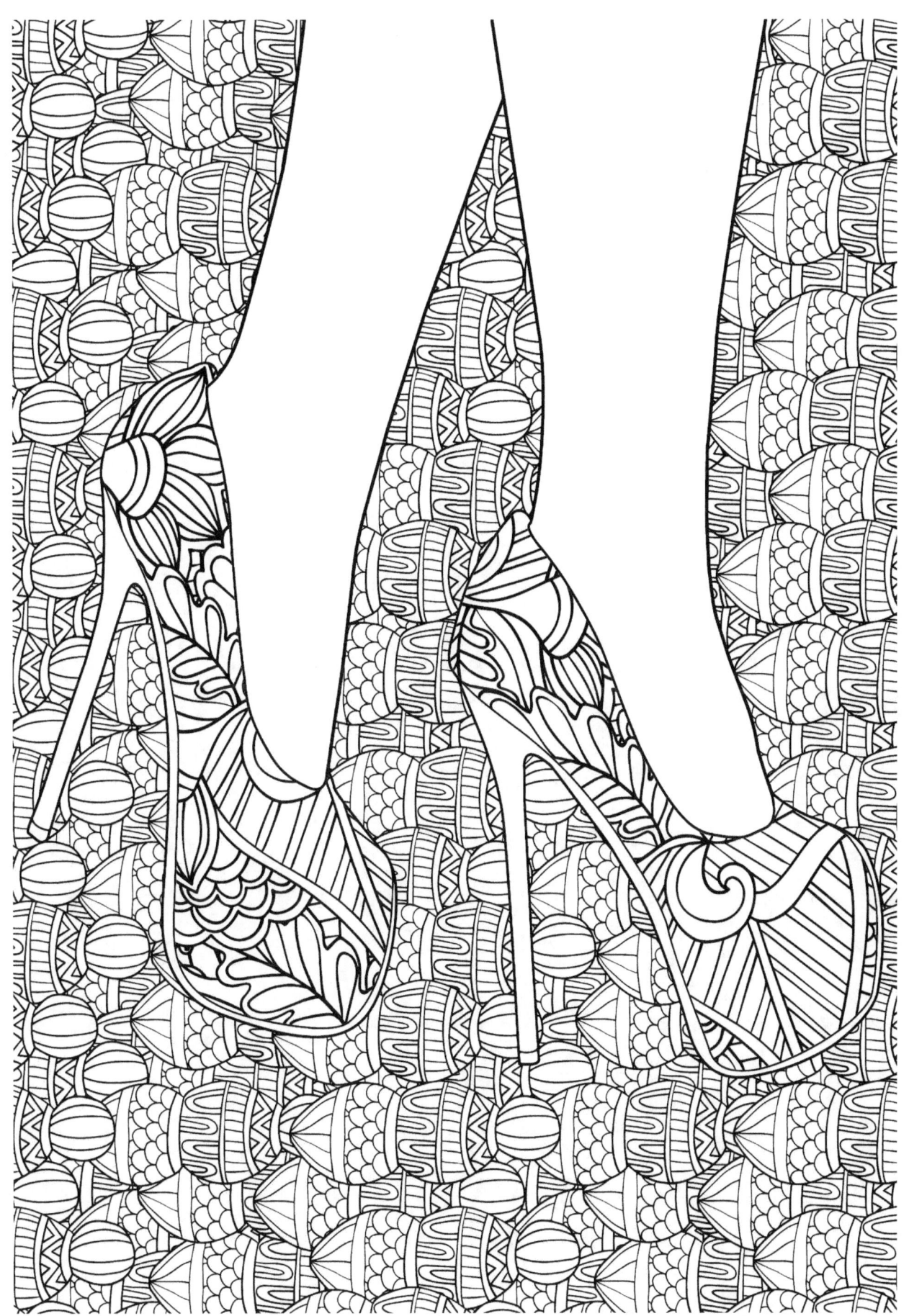

PALETTE BARS
*USE THESE SQUARES TO TEST YOUR COLORING MEDIUM AND PALETTE.
DONT BE AFRAID TO TRY DIFFERENT COLOR COMBINATIONS.*

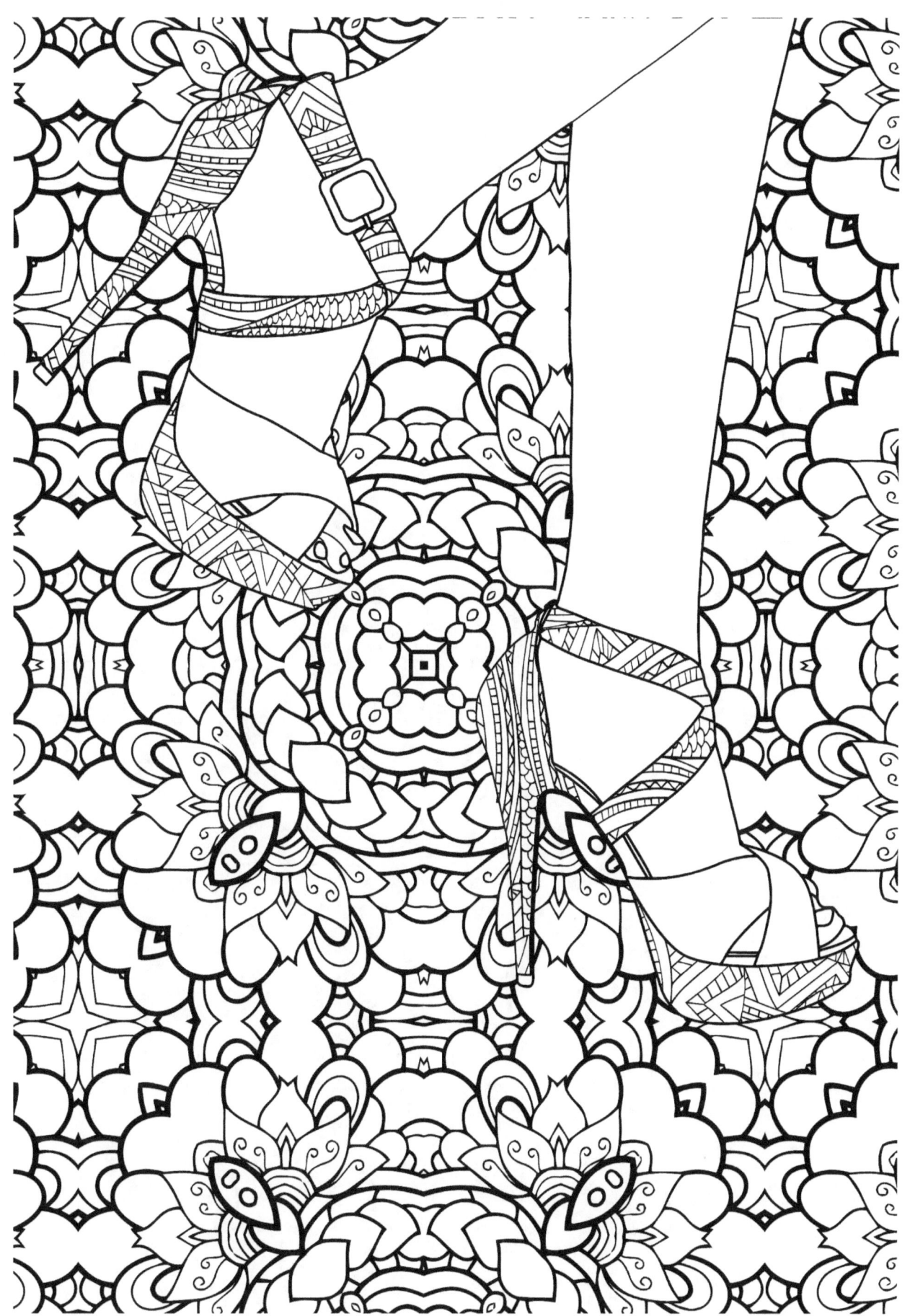

PALETTE BARS
*USE THESE SQUARES TO TEST YOUR COLORING MEDIUM AND PALETTE.
DONT BE AFRAID TO TRY DIFFERENT COLOR COMBINATIONS.*

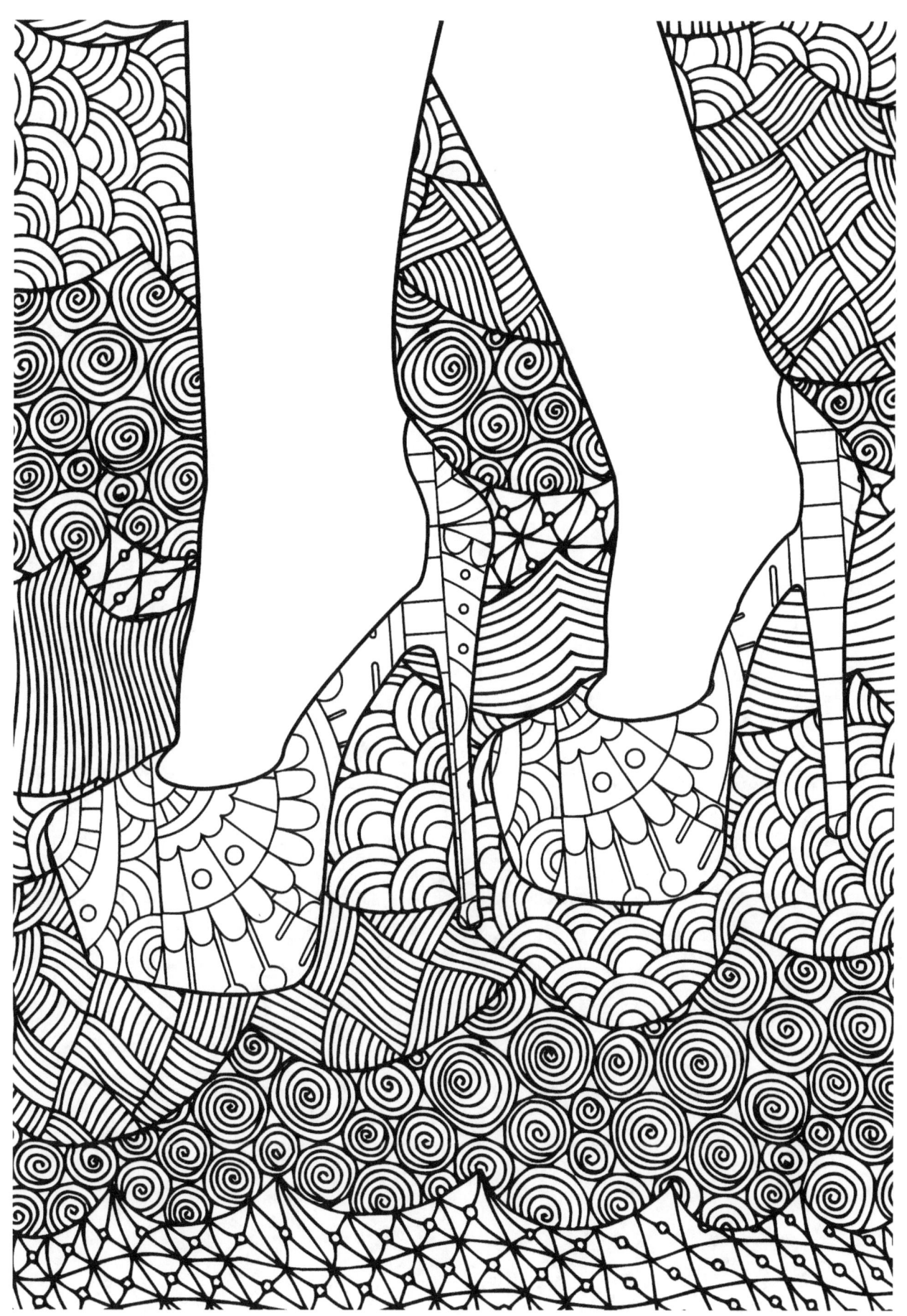

PALETTE BARS
*USE THESE SQUARES TO TEST YOUR COLORING MEDIUM AND PALETTE.
DONT BE AFRAID TO TRY DIFFERENT COLOR COMBINATIONS.*

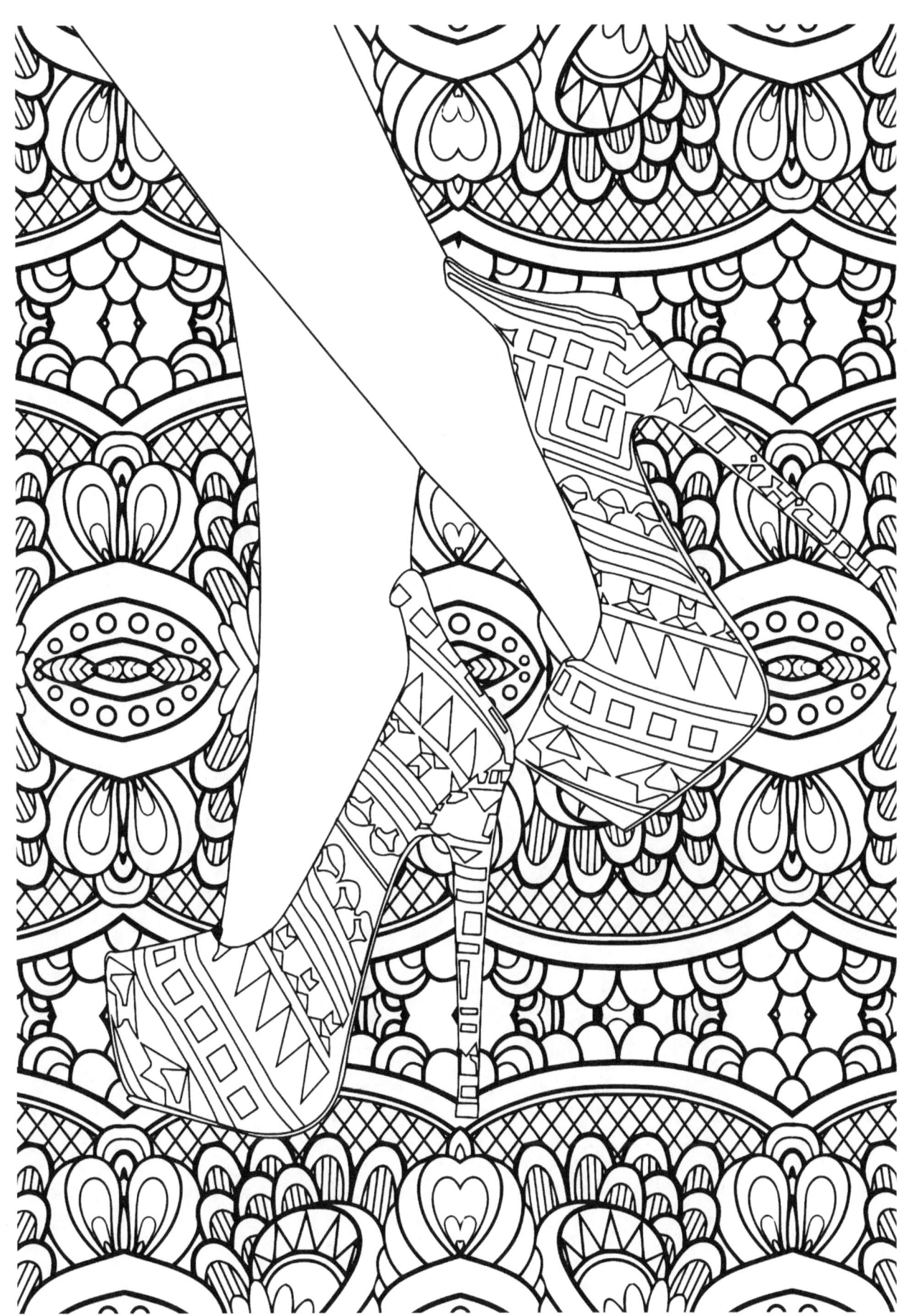

PALETTE BARS
*USE THESE SQUARES TO TEST YOUR COLORING MEDIUM AND PALETTE.
DONT BE AFRAID TO TRY DIFFERENT COLOR COMBINATIONS.*

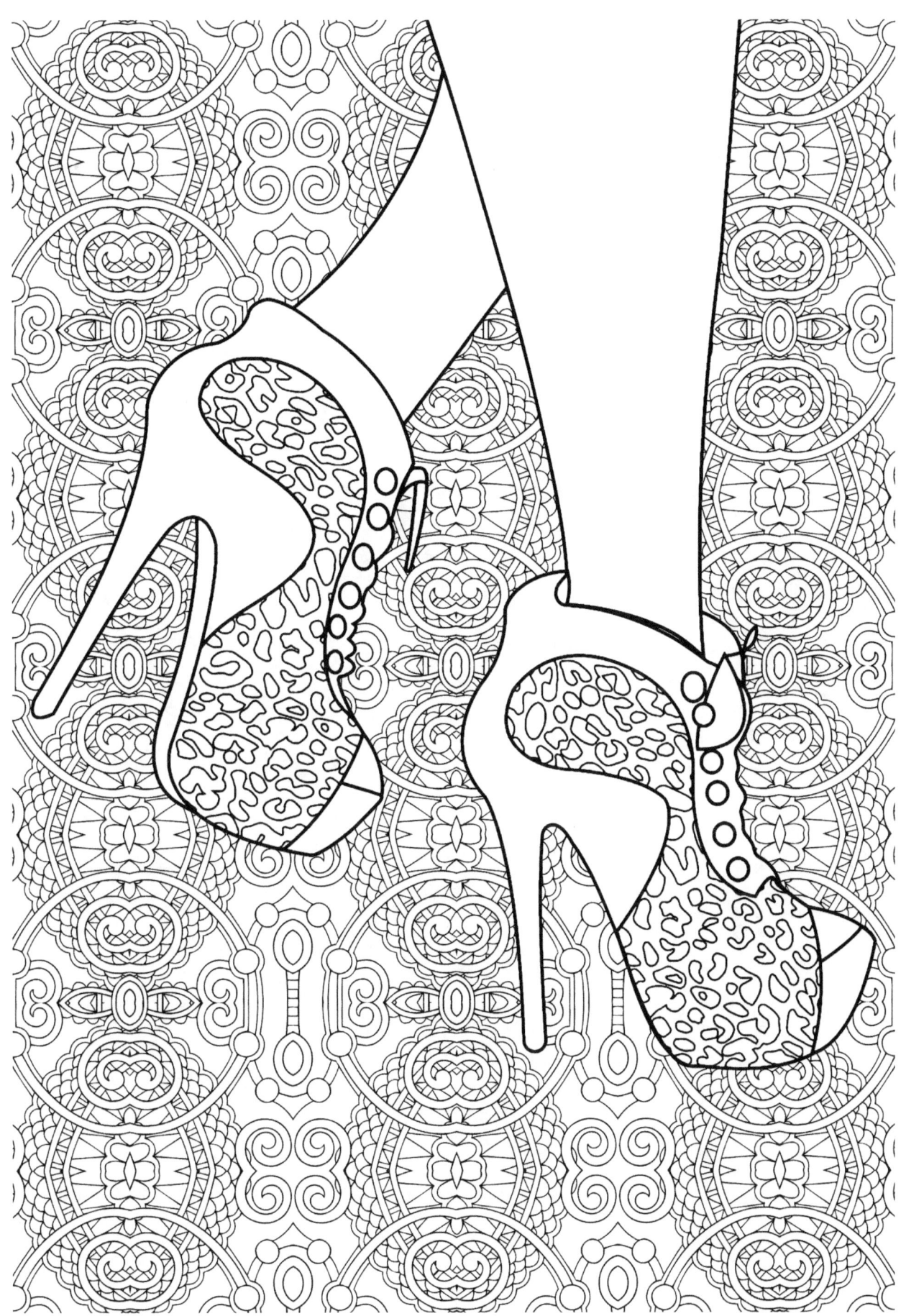

PALETTE BARS
*USE THESE SQUARES TO TEST YOUR COLORING MEDIUM AND PALETTE.
DONT BE AFRAID TO TRY DIFFERENT COLOR COMBINATIONS.*

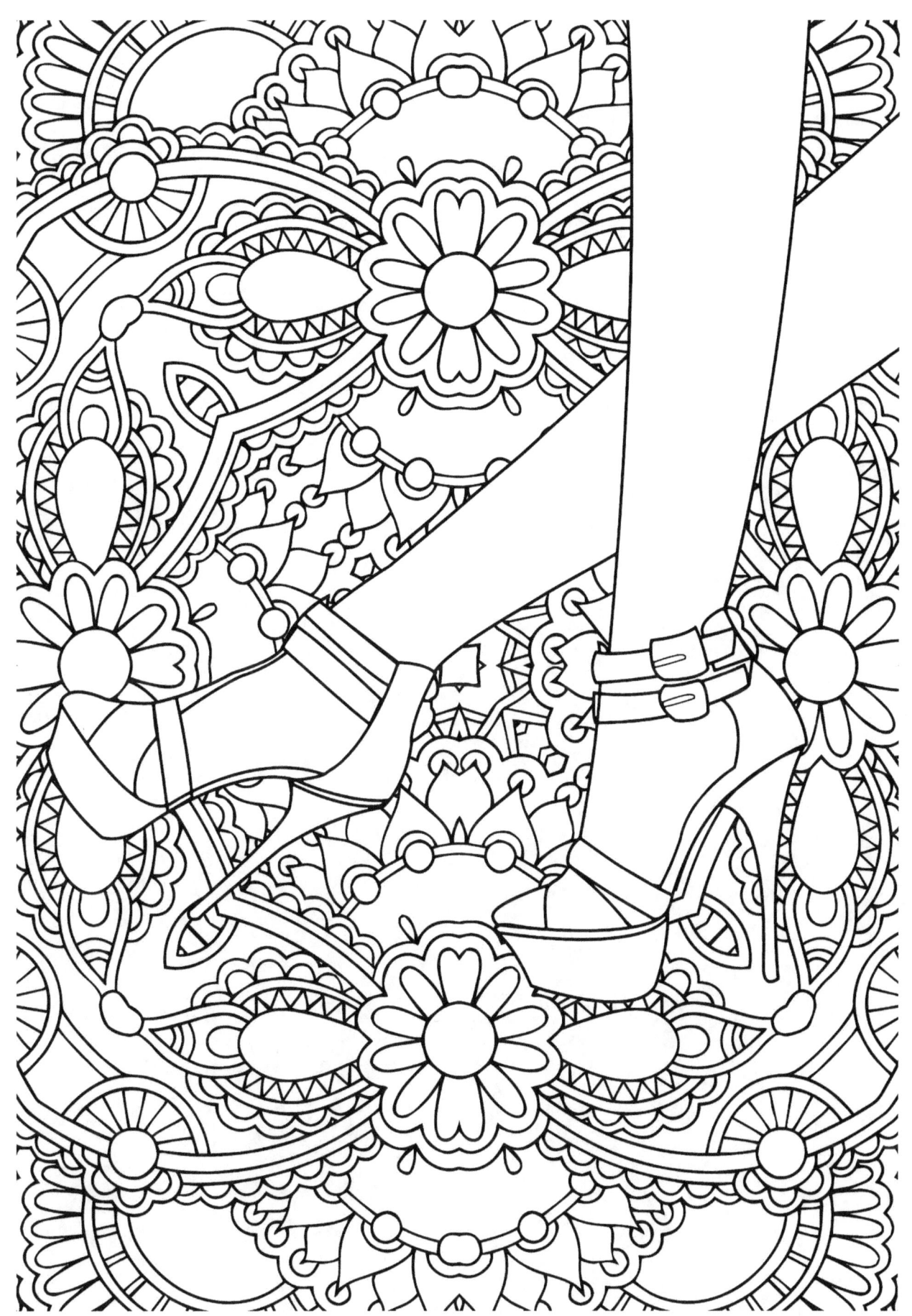

PALETTE BARS
*USE THESE SQUARES TO TEST YOUR COLORING MEDIUM AND PALETTE.
DONT BE AFRAID TO TRY DIFFERENT COLOR COMBINATIONS.*

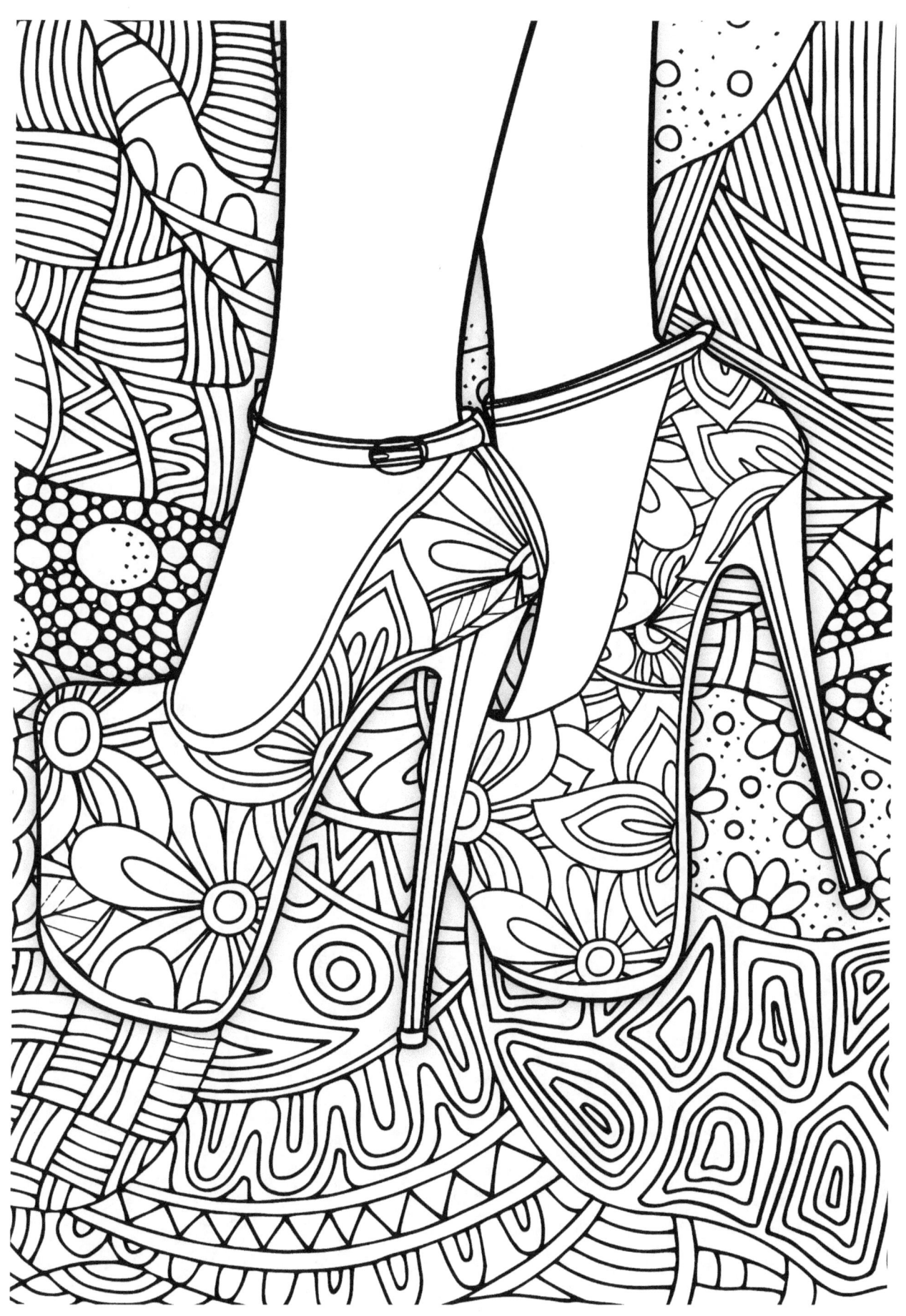

PALETTE BARS
USE THESE SQUARES TO TEST YOUR COLORING MEDIUM AND PALETTE.
DONT BE AFRAID TO TRY DIFFERENT COLOR COMBINATIONS.

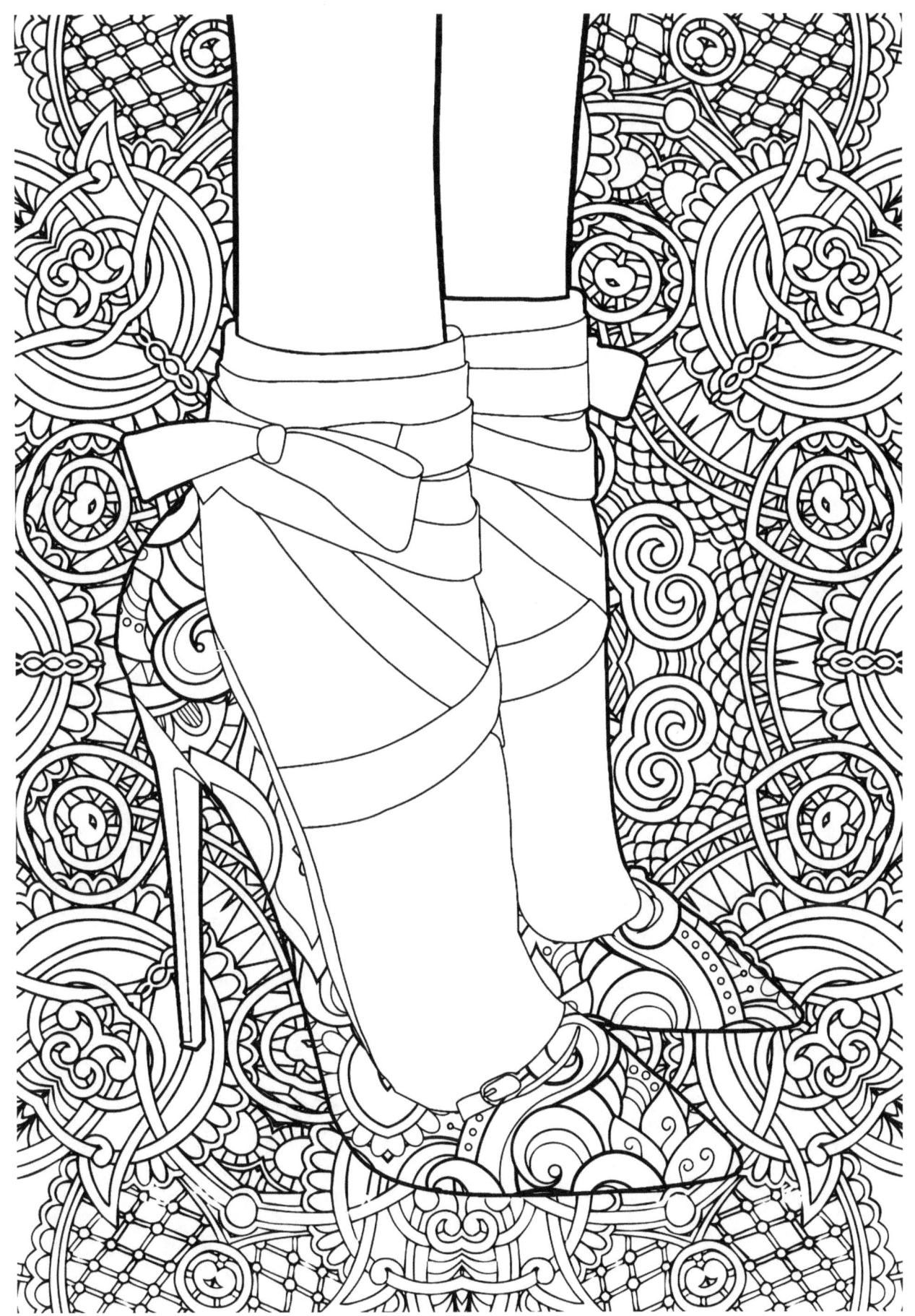

PALETTE BARS
USE THESE SQUARES TO TEST YOUR COLORING MEDIUM AND PALETTE.
DONT BE AFRAID TO TRY DIFFERENT COLOR COMBINATIONS.

www.ingramcontent.com/pod-product-compliance
Lightning Source LLC
Chambersburg PA
CBHW080724190526
45169CB00006B/2504